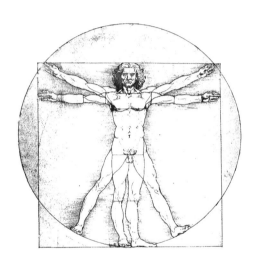

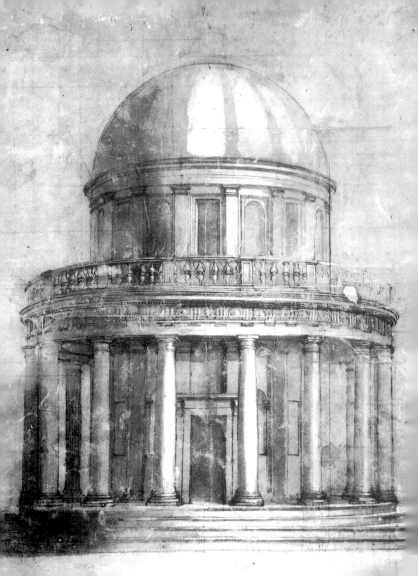

RENAISSANCE

TRACY E. COOPER

ABBEVILLE
STYLEBOOKS™

ABBEVILLE PRESS · PUBLISHERS
NEW YORK · LONDON · PARIS

CONTENTS

INTRODUCTION

*This age, like a golden age, has restored to light
the liberal arts that were almost extinct: grammar, poetry,
rhetoric, painting, sculpture, architecture, music.*
—Marsilio Ficino, letter to a German correspondent, 1492

Renaissance, *rinascita*, rebirth. Both the concept of the Renaissance as the period 1400–1600 and the term itself derive from mid-nineteenth-century French historians. Jacob Burckhardt's *Civilization of the Renaissance in Italy* (1860) associated the fifteenth and sixteenth centuries with Italian culture, and the popular image of the Renaissance was born. The validity of applying the Renaissance label to a historical period continues to be debated. It may be most meaningfully described as a style, which is how it was seen in its own time—a style based on the revival of Italian arts and letters, exemplified by the creations of Michelangelo Buonarroti, Raphael, and Leonardo da Vinci.

Giorgio Vasari undertook his *Lives of the Artists* (1550, 1568) after a dinner conversation at the table of Cardinal Alessandro Farnese in Rome convinced him that he should provide an account of how the renaissance in the arts had come about. The modern style was presented as a corrective to Greek, German, and Gothic styles because of its superior adherence to the art of classical antiquity. Of course, there was a political cast to this judgment, for Italy could reasonably claim itself the native heir to Rome. The great fourteenth-century writer and scholar Petrarch had castigated his own day as the "dark" age and held

up the shining example of the greatness of the Roman past, admired for both republican virtues and imperial ambitions. For the arts, Rome was a visible legacy. In Vasari's mind, the imitation of nature was key to the enterprise of reclaiming that past.

Renaissance style was indisputably Italian, nourished on the classical past, although its typical Italian elements were transformed during the fifteenth and sixteenth centuries. "Typical" Italian elements included an extraordinary richness and diversity of styles, some more or less recognized, such as Mannerism. Within Italy itself there was great variety in geography, political organization, and artistic influences. Milan, because of its proximity to France, had stronger ties to contemporary Gothic style. For Florence and Venice, shaping a republican identity was an important goal in their cultural politics; independence from the Gothic and adherence to a new style steeped in the local past furthered the expression of their goals.

The success of the Renaissance style was not confined to Italy but developed a momentum that carried it to other European centers such as England and Germany, France and Spain. Outside Italy acquiring Renaissance style initially meant becoming Italianate. The style was adopted at the courts of Francis I in France, Henry VIII and Elizabeth I in England, Philip II in Spain, and Charles V and Rudolf II in the Holy Roman Empire, although some time elapsed before this change occurred on a large scale. Often at first only details of Italian style mixed with the vernacular, but ultimately an independent classicism evolved. The widespread assimilation of Renaissance principles throughout Europe fulfilled the promise of cultural rebirth.

THE AGE OF EXPLORATION

With good reason the Renaissance has been called the Age of Exploration. The voyages of Christopher Columbus, Amerigo Vespucci, Vasco da Gama, Ferdinand Magellan, Francisco Pizarro, Hernando Cortés, and Bartolomeu Dias opened new routes to the Indies and across the Atlantic to the Americas. Together with Nicolaus Copernicus and Galileo Galilei's speculations about the heavens, they forever changed humans' view of the world.

A Renaissance astronomer in his study is surrounded by instruments of discovery—globes, compasses, quadrants, sailing ships, books, and maps.

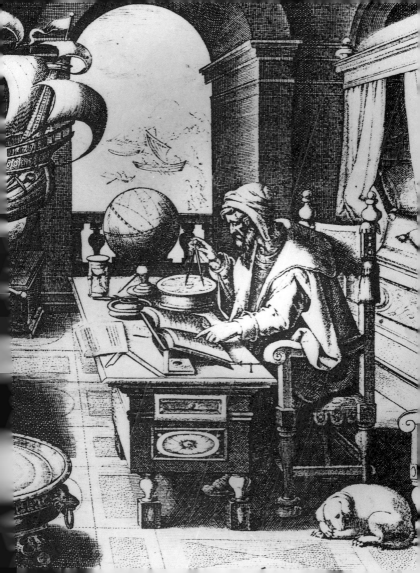

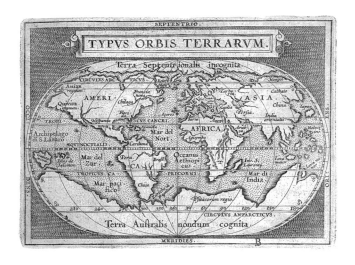

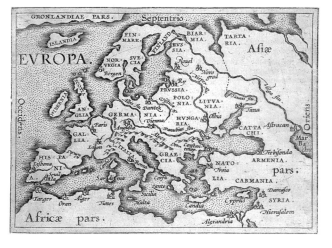

The distinguishing attribute of the Renaissance was a changed notion of history. Awareness of modernity developed—recognition of the present as distinct from the classical past. Humanists recouped Petrarch's understanding, a century earlier, of his place in history and reclaimed the modern for their own. It became an age in which the *studia humanitatis* (humanities) flourished again.

Rather than being viewed as a random unfolding of events, history was accorded a classical structure and purpose. Led first by a quest for the literary purity of ancient Latin, Greek, and Arabic texts, humanism in turn led to the evaluation of events and evidence that became modern history. Giorgio Vasari shared this sense of being a modern man and based his *Lives of the Artists* on the idea of progress.

Modernity was comparative. The present age was a Golden Age, its achievements worthy of the ancients. Nostalgia produced the dream of Arcadia, recreated in the pastoral life of the villa. Optimism for the future constructed a vision of Utopia, an ideal society whose buildings would further its perfection.

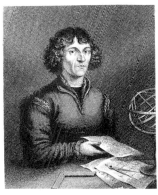

Nicolaus Copernicus reexamined theories of the classical astronomer Ptolemy and concluded that the earth revolved around the sun.

The early moderns took control of how space was represented, as in map making, even as they looked back to ancient knowledge. These maps are from a 1589 atlas compiled by Abraham Ortelius.

	1400	1410	1420	1430	1440	1450	1460	1470	1480	1490

POLITICS & SOCIETY

- Council of Constance ends "Great Schism"
- Cosimo ("the Elder") de' Medici returns from exile to Florence
- Hapsburgs become Holy Roman Emperors
- Latin and Greek Churches unite
- Constantinople falls
- Wars of the Roses begin
- Maximilian of Austria marries Mary of Burgundy
- Aragon and Castile are unified
- Spanish Inquisition begins
- Tudor dynasty established
- Dias sails around Cape of Good Hope
- Columbus crosses Atlantic Ocean
- First terrestrial globe fashioned
- Jews and Moors expelled from Spain
- Charles VIII invades Italy
- Vasco da Gama discovers route to India

LITERATURE & PERFORMING ARTS

- Panygyric of the City of Florence (Bruni)
- Ficino's translation of Plato's Dialogues
- Early printed music
- Imitation of Christ (Thomas à Kempis)
- La belle dame sans merci (Chartier)
- Emergence of Modern English from Middle English
- Dufay motet in honor of Florence Duomo
- Vatican Library
- Dunstable's compositions in counterpoint
- Printing with metal plates for "42-Line Bible" (Mainz)
- Platonic Academy in Florence
- Divine Comedy (Dante)
- First printed book in English (Bruges)
- Ballet at Italian courts
- Josquin des Prés choirmaster at Cambrai Cathedral
- Arcadia (Sannazaro)
- Oration on the Dignity of Man (Pico della Mirandola)

VISUAL ARTS & DESIGN

- Competition for north doors, Florence Baptistery
- St. John the Baptist (Ghiberti)
- Fonte Gaia (della Quercia)
- Adoration of the Magi (da Fabriano)
- Trinity (Masaccio)
- Gattamelata (Donatello)
- Gates of Paradise, Florence Baptistery (Ghiberti)
- Ovetari Chapel (Mantegna)
- Legend of the True Cross (Piero)
- David (Donatello)
- Tomb of the Cardinal of Portugal (Rossellino et al.)
- Sistine Chapel walls (Botticelli, Ghirlandaio, Perugino, et al.)
- Doubting of Thomas (Verrochio)
- Frari Altarpiece (Giovanni Bellini)
- Dürer's visit to Venice
- Last Supper (Leonardo)
- Scenes of the Antichrist (Signorelli)

	1400	1410	1420	1430	1440	1450	1460	1470	1480	1490

1500	1510	1520	1530	1540	1550	1560	1570	1580	1590	1600

POLITICS & SOCIETY

- League of Cambrai formed
- Luther posts *95 Theses*
- Cortés conquers Mexico
- Rome sacked
- Turks lay siege to Vienna
- Pope crowns Charles V Holy Roman Emperor
- Henry VIII declared supreme head of church in England
- Halley's Comet sighted
- Calvin's *Institutes* published
- Jesuit Order confirmed
- *On the Revolutions of Celestial Spheres* (Copernicus)
- French Wars of Religion begin
- Council of Trent meets in final session
- Turks defeated at Battle of Lepanto
- St. Bartholomew's Day Massacre
- Spanish Armada sails for England
- *On Motion* (Galileo)
- Edict of Nantes proclaimed

LITERATURE & PERFORMING ARTS

- *In Praise of Folly* (Erasmus)
- *Utopia* (More)
- *Orlando Furioso* (Ariosto)
- *The Courtier* (Castiglione)
- *The Prince* (Machiavelli)
- *Pantagruel and Gargantua* (Rabelais)
- *Amours* (Ronsard)
- *Heptameron* (Margaret of Navarre)
- Zarlino's definition of modern scales
- *Rinaldo* (Tasso)
- Invention of cello in Cremona
- *Essays* (Montaigne)
- *Galatea* (Cervantes)
- Monteverdi's first book of madrigals
- *Faerie Queen* (Spenser)
- *Arcadia* (Sidney)
- *Henry VI* (Shakespeare)
- *Dafne* (Peri), first opera
- Globe Theater, London

VISUAL ARTS & DESIGN

- *David* (Michelangelo)
- *Mona Lisa* (Leonardo)
- *Four Apostles* (Dürer)
- *The Tempest* (Giorgione)
- Sistine Chapel ceiling (Michelangelo)
- Pietro Torregiani in England
- *Stanze* (Raphael), Vatican Palace
- *Assumption of the Virgin* (Titian)
- *Portrait of Erasmus of Rotterdam* (Holbein)
- *Vision of St. John the Evangelist* (Correggio)
- *Last Judgment* (Michelangelo), Sistine Chapel
- *Autobiography* (Cellini)
- Florentine Academy of Design
- *The Four Books of Architecture* (Palladio)
- Veronese before Inquisition for *Feast in the House of Levi*
- *Rape of the Sabines* (Gianbologna)
- *Paradise* (Tintoretto)
- *View of Toledo* (El Greco)

1500	1510	1520	1530	1540	1550	1560	1570	1580	1590	1600

**Population Growth,
1500–1600**

France: 16 to 19 million

Germany: 12 to 16
million

Castile: 3 to 6 million

England: 3 to 6 million

Southern Italy: 3 to 6
million

In the fresco *Duke
Ludovico Gonzaga
Seated with His Court*
(1474, Andrea Man-
tegna), the duke is
shown as pater familias.

The construction of
ideal buildings and
ordered worksites, as
depicted in *Building of
a Double Palace* (ca.
1515, Piero di Cosimo)
(pages 16–17), offered
patrons a metaphor
for the construction of
an ideal society.

A new awareness of self was accompanied by a growing sense of individual style. Discrimination and taste developed, generating among the upper classes and the wealthy an appetite for the new fashion.

Standards of living afforded wider access to comfort. Urban economies benefited from preindustrial capitalism. Trade and banking were forces of prosperity. Hierarchy, a social principle, was reflected in Renaissance architecture, from the ordering of the ideal city to the arrangement of rooms in houses.

Merchants and diplomats aided cultural cross-fertilization. Political systems and constitutional forms varied from communes to city-states, despotic courts to oligarchical republics; European monarchies were in transition from feudal to sovereign, and state bureaucracies began to emerge. Christendom was replaced by the new geographic, secular entity of Europe, aided by the Protestant Reformation in northern Europe and the Counter Reformation in Catholic lands. In Italy, despite Rome's acknowledged spiritual authority, the city-states' identity inhibited the development of any sense of nationality, and they never united to form a modern sovereign nation.

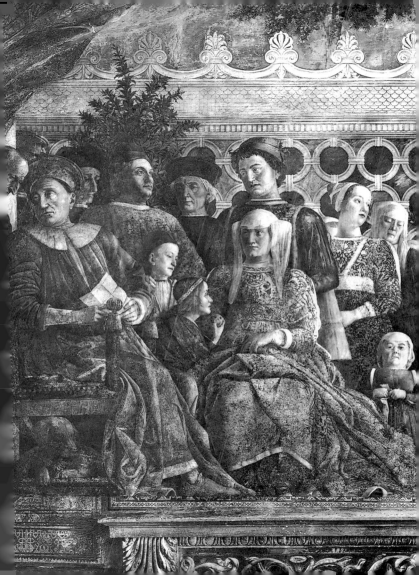

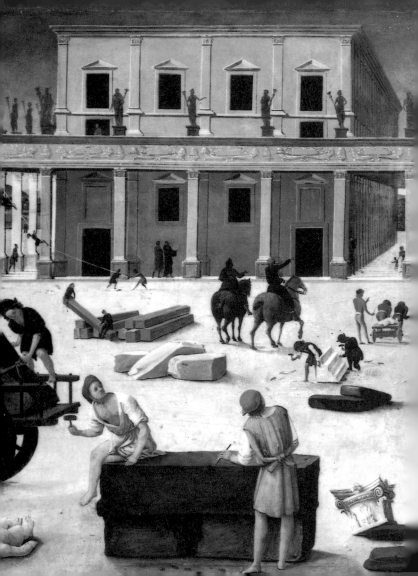

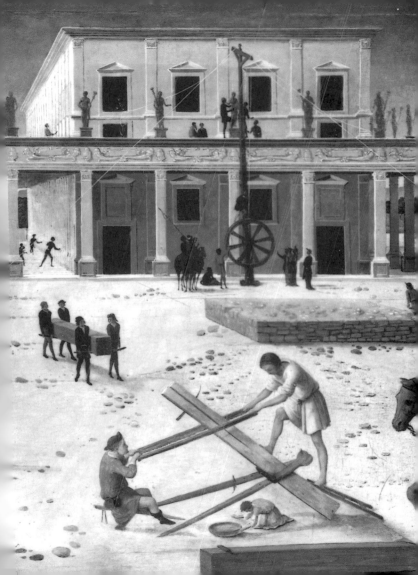

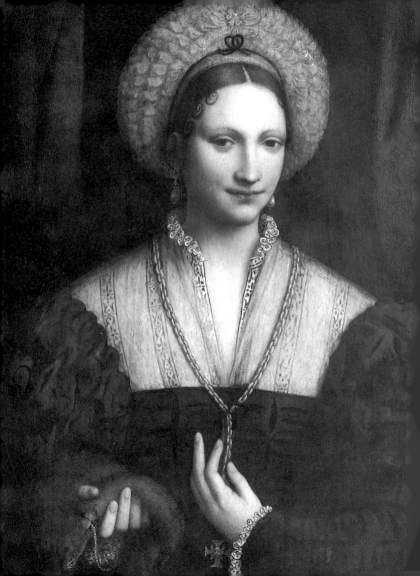

PERSONAL STYLE

The proper deportment for the new age was prescribed by several manuals that disseminated the prescribed decorum for Italian humanist courts. One of the best known was *The Courtier* (1528) by Baldassare Castiglione, who provided models of dress, manners, entertainment, and expertise in the arts, including love and war. Niccolò Machiavelli's *The Prince* (1532) presented another, more sinister face in its shrewd political observations.

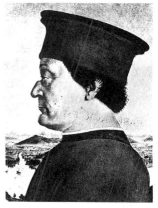

The patronage of Duke Federico II da Montefeltro. shown in a 1472 portrait by Piero della Francesa, made Urbino a center of refined taste.

Fashion was the province of the aristocratic and the wealthy. As an aesthetic based on antiquity fueled a transformation in the arts in Italy, so too taste changed from the Gothic to a new style that reverberated throughout Europe. The slim, elongated Gothic profile gave way to a more sculptured look that emphasized the body.

Clothing of the period was multilayered. Women wore a chemise and stockings, a simple wool dress, over that a gown of richer material, such as figured velvet or silk, and a mantle and some type of headwear for outdoors. Men wore a shirt and hose, doublet, and tunic, plus a mantle for outdoors; a cap replaced the earlier long hood.

Bernardino Luini's *Portrait of a Lady* (1520) displays the ultimate in jewelry, a *zibellino* (jeweled sable head). For men the most popular jewelry was the *enseigne* (hat badge).

ART WITH A PURPOSE

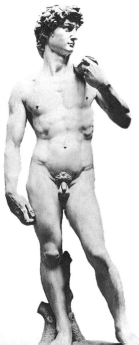

Michelangelo's *David* (1501) (below) and Leonardo's *Mona Lisa* (1503) (opposite) represent a range of purposes that art could fulfill, from sculpture on public display to portraits in private homes.

The practice of the arts was bound by strict guild regulations that increasingly conflicted with artists' ambitions. Artists sought to separate their profession from the crafts and raise it to the liberal arts (along with grammar, rhetoric, dialectic, arithmetic, geometry, astronomy, and music), arguing that their work was an intellectual exercise rather than manual labor.

Architecture, by virtue of its mathematical ratios and harmonies, was easily accepted as a liberal art. But the idea of the professional architect as a trained specialist was not yet the norm; a background in painting or sculpture was seen as necessary for training in perspective and drawing. The engineering and construction processes could be left to masons and carpenters; the architect was responsible for a building's design.

Much of Renaissance art was integrated into specific architectural settings. Art generally performed a function, whether as a wall covering in a house or an altarpiece in a church. Collecting and display, especially of antiquities, became more purposeful. The Capitoline (1538–69) in Rome received the first public gift of such a collection of classical art.

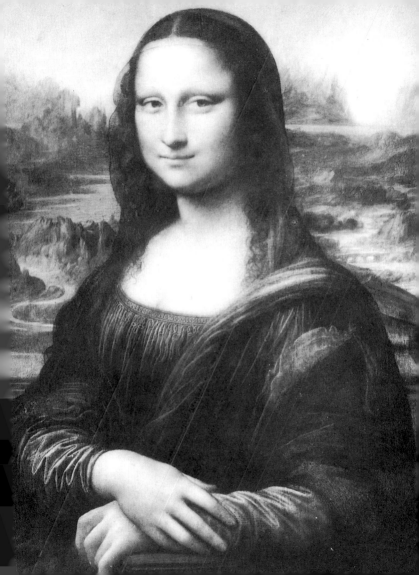

The invention of printing with movable type was the most radical change in the arts. Johann Gutenberg first produced printed books in Mainz around 1450. The technology spread to Rome by 1467, accompanied by the use of paper and oil-based inks. Books had previously been for the elite, because manuscripts were rare and costly to produce. Now a new world of ideas was opened to a broader spectrum; literacy rose. The Bible was the first best-seller. By the sixteenth century, drawings on paper were in common use for artists and architects. Fra Giocondo's architectural treatise of Vitruvius (1511) led to the how-to manual, epitomized by Andrea Palladio's *Four Books of Architecture* (1570).

The invention of gunpowder and discovery of propulsion principles affected the design of fortresses and cities. Attendant changes in warfare led to new tactics. While surveying for the infamous Cesare Borgia, Leonardo da Vinci projected a new technique for mapping from a bird's-eye view. The resulting angled bulwark shifted tactics from defense to offense.

Early print shops became centers of intellectual exchange.

The design and layout of early printed books were derived from illuminated manuscripts. Bernardus Pictor made the border designs and initials for this volume printed by Erhart Ratdolt.

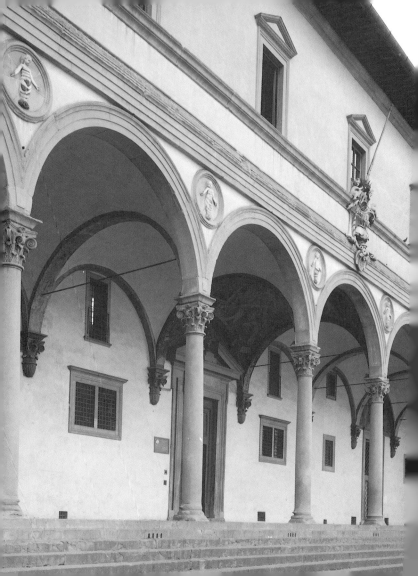

RENAISSANCE STYLE

Successive phases of the Renaissance can be characterized by their relation to the classical past, nature, and science. The early period (1400–1475) saw a dawning awareness and sense of discovery; the High Renaissance (1475–1520) identified with the rebirth of Rome and mastery of the arts; the Late Renaissance (1520–1600), also known as Mannerism, outdid its models and extended the international impact of the Renaissance style beyond its Italian birthplace.

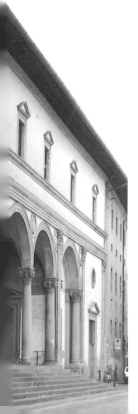

Filippo Brunelleschi's arcaded Foundling Hospital (1419–40), Florence, with its della Robbia roundels, has often been called the first Renaissance building.

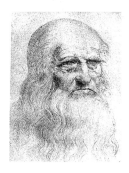

The features of the aged Leonardo da Vinci in his 1512 self-portrait (above) were the model for Plato's in Raphael's fresco *School of Athens* (1511) (opposite). The great domed space mirrors Donato Bramante's ambitions for the new St. Peter's. Bramante may have known Leonardo's ideas from Milan; both worked at Santa Maria delle Grazie, where Leonardo painted his *Last Supper* (ca. 1498).

A roll call of the formative personalities of the Renaissance would produce an astounding number of geniuses in almost every modern discipline: in religion, Martin Luther, John Calvin, St. Ignatius of Loyola, and John Knox; in humanism, Desiderius Erasmus, Thomas More, Marsilio Ficino, and Michel de Montaigne; in literature, William Shakespeare, Lope de Vega, Lodovico Ariosto, and Torquato Tasso; in astronomy, Nicolaus Copernicus, Tycho Brahe, and Galileo Galilei; in anatomy, Andreas Vesalius and William Harvey; in alchemy, Paracelsus; in history, Francesco Guicciardini, Flavio Biondo, and Jean Bodin; and in political theory, Niccolò Machiavelli.

With his inquiring mind, Leonardo da Vinci exemplifies the spirit of the age. In his voluminous notebooks he recorded his observations of swirling river currents as well as the human body's inner life force. The principles he developed propelled his art. From the circle, the most perfect platonic form, he drew plans for centralized churches. Observing the changes in color over distance and through air, he developed a theory of aerial perspective, visible in the craggy distant landscape of the *Mona Lisa* (1503).

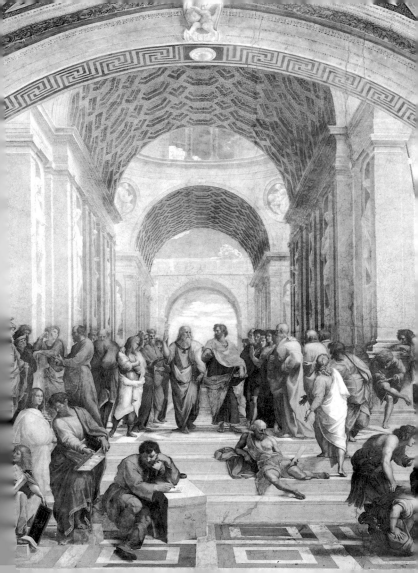

ARCHITECTS

Galeazzo Alessi (1512–72)
Santa Maria di Carignano
(1552), Genoa

**Bartolomeo Ammannati
(1511–92)**
Garden facade (1560),
Pitti Palace, Florence

**Donato Bramante
(1444–1514)**
Il Tempietto (1503), Rome;
Caprini Palace (1510), Rome

**Filippo Brunelleschi
(1377–1446)**
Cathedral dome (1420–34),
Florence

Jean Bullant (ca. 1520–78)
Valois Chapel (1578), St. Denis

**Mauro Codussi
(ca. 1440–1504)**
San Michele in Isola (1470s),
Venice

Peter Flötner (ca. 1485–1546)
Hirschvogelsaal (1534),
Nuremberg

**Juan de Herrera
(ca. 1530–97)**
Royal Church (1580),
El Escorial, near Madrid

Luciano Laurana (ca. 1420–79)
Ducal Palace (1468–79),
Urbino

Pierre Lescot (ca. 1500–1578)
Hôtel Carnavalet (1550), Paris

Pirro Ligorio (ca. 1510–83)
Casino of Pius IV (1562),
Gardens, Vatican City

Pedro Machuca (d. 1550)
Royal Palace (1539–68),
Granada

**Michelangelo Buonarroti
(1475–1564)**
New St. Peter's (1546–64),
Vatican City

**Michelozzo Michelozzi
(1396–1472)**
Medici Palace (1446–59),
Florence

**Baldassare Peruzzi
(1481–1536)**
Villa Farnesina (1509–21),
Rome

**Giacomo della Porta
(ca. 1537–1602)**
Il Gesù facade (1571–84),
Rome

Raphael (1483–1520)
Villa Madama (1527), Rome

**Giulio Romano
(ca. 1492–1546)**
Palazzo del Tè (1534), Mantua

**Biagio Rossetti
(ca. 1447–1516)**
Ercolean addition (1490s),
Ferrara

**Antonio da Sangallo the Elder
(1455–1534)**
Madonna di San Biagio (1526),
Montepulciano

**Giuliano da Sangallo
(1445–1516)**
Santa Maria delle Carceri
(1492), Prato

**Jacopo Sansovino
(1486–1570)**
Proto of St. Mark's (1529),
Venice

**Vincenzo Scamozzi
(1552–1616)**
Rocca Pisana (ca. 1576), Lonigo

**Robert Smythson
(ca. 1536–1614)**
Wollaton Hall (1588),
Nottinghamshire

**Juan Bautista de Toledo
(d. 1567)**
Royal Palace (1563–82),
El Escorial, near Madrid

MILITARY ARCHITECTS

**Bernardo Buontalenti
(ca. 1536–1608)**
Belvedere Fort (1595),
Florence

**Domenico Fontana
(1543–1607)**
Obelisk (1585), Vatican City

**Leonardo da Vinci
(1452–1519)**
Plan of Imola (1502)

**Antonio da Sangallo
the Younger (1485–1546)**
Rocca (1542), Castro

**Michele Sanmicheli
(ca. 1484–1559)**
Sant'Andrea a Lido (1535–49),
Venice

FOUNTAIN DESIGNERS

Gianbologna (1529–1608)
Neptune Fountain (1563),
Bologna

**Giovanni Montorsoli
(ca. 1507–63)**
Neptune Fountain (1551),
Messina

**Jacopo della Quercia
(ca. 1380–1438)**
Fonte Gaia (1419), Siena

THEORISTS	PUBLIC LEADERS	ARTISTS
Leon Battista Alberti (1404–72) *Ten Books of Architecture* (1452, pub. 1485)	**Alfonso 4, Naples (1448–95)** Poggioreale (1489), Naples	**Donatello (ca. 1385–1466)** *David (ca. 1446–50); Gattamelata (1453)*
Benvenuto Cellini (1500–1571) *Autobiography* (1562)	**Charles V, Holy Roman Empire (1500–1558)** Royal Palace (1539–68), Granada	**Albrecht Dürer (1471–1528)** *Four Apostles (1504)*
Philibert de l'Orme (ca. 1515–70) *First Book of Architecture* (1568)	**Federico II da Montefeltro, Duke of Urbino (1422–82)** Ducal Palace (1468–79), Urbino	**Lorenzo Chiberti (1378–1455)** *St. John the Baptist (1405–17); Gates of Paradise (1425–52),* Baptistery, Florence
Jacques Androuet du Cerceau (ca. 1520–ca. 1585) *The Most Excellent Buildings of France (1576, 1579)*	**Francis I, France (1494–1547)** Fontainebleau additions (1528–40s)	**Leonardo da Vinci (1452–1519)** *Last Supper (ca. 1498); Mona Lisa (1503)*
Antonio Filarete (ca. 1400–1469) *Ms. Treatise on Architecture* (1460–64)	**Henry II, France (1519–59)** Louvre Palace, Square Court (1551), Paris	**Masaccio (1401–ca. 1428)** *Trinity (ca. 1426)*
Francesco di Giorgio Martini (1439–ca. 1501) *Ms. Treatise on Architecture* (1456)	**Henry VIII, England (1491–1547)** Hampton Court additions (1532–37), London	**Michelangelo Buonarroti (1475–1564)** *Pietà (1500); Sistine Ceiling (1512)*
Fra Giocondo (ca. 1433–1515) First illustrated Vitruvius, *Ten Books of Architecture* (1511)	**Cosimo ("the Elder") de' Medici, Florence (1389–1464)** San Lorenzo (Old Sacristy, 1428), Florence; Medici Palace (1446–59), Florence	**Raphael (1483–1520)** *Galatea (1513); Stanze (1514)*
Andrea Palladio (1508–80) *The Four Books of Architecture* (1570)	**Philip II, Spain (1527–98)** El Escorial (1563–82), near Madrid	**Titian (ca. 1489–1576)** *Assumption of the Virgin (1518)*
Sebastiano Serlio (1475–1554) *General Rules of Architecture* (in seven books, 1537–75)	**Pope Julius II (1443–1513)** New St. Peter's (1506–1614), Vatican City	**WRITERS**
John Shute (d. 1563) *The First and Chief Groundes of Architecture* (1563)	**Pope Leo X (1475–1521)** Medici Chapel and Library (1519–34), Florence	**Baldassare Castiglione (1478–1529)** *The Courtier* (1528)
Giorgio Vasari (1511–74) *Lives of the Artists* (1550, rev. ed. 1568)	**Pope Paul III (1468–1549)** Farnese Palace (1517–64), Rome	**Miguel de Cervantes (1547–1616)** *Galatea* (1585)
Giacomo da Vignola (1507–73) *Rules for the Five Orders (1562)*	**Pope Sixtus V (1525–90)** Via Sistina (1590), Rome	**Michel de Montaigne (1533–92)** *Essays* (1580)
		William Shakespeare (1564–1616) *Two Gentlemen of Verona* (1594)

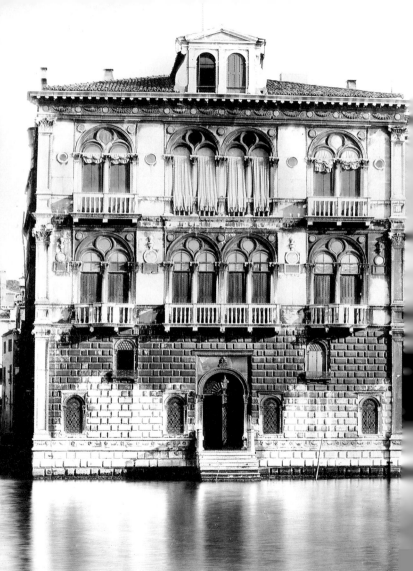

EARLY RENAISSANCE

In trying to recover the classical past, Early Renaissance style became an amalgam of local building traditions and classical architecture. Adaptations of older medieval styles—such as a local version of Tuscan Romanesque or, as in the Ca' d'Oro (1421–36) in Venice, the Byzantine mode—provided a patrimony to be marshalled against contemporary Gothic style; the latter was associated with northern Europe, especially the courts of France and Burgundy.

Abundant remains of ancient architecture and sculpture were indiscriminately mined for examples. The development of different period styles within classical art itself was not yet well understood, however. Extant classical buildings often seemed to contradict the major architectural treatise to survive from antiquity, Vitruvius's *Ten Books of Architecture,* written in the late first century B.C. Greek architecture was not comprehended as a distinct phenomenon because so little of it was known firsthand.

Early in the Renaissance, the pedigree of antiquity was even applied to important medieval buildings. The Florence Baptistery, for example, was incorrectly thought to have originally been a temple of Mars.

In the Corner-Spinelli Palace (1490s, Mauro Codussi), Venice, exuberant colored marbles and Veneto-Byzantine arched windows have given way to a more sober tripartite facade of Istrian stone. It reflects the interior plan and allows light to penetrate the long salon.

The reason round arches are more beautiful than pointed ones is plain, for everything that impedes the vision ... is not as beautiful as the line that the vision follows and thus the eye has nothing to hinder it.—Antonio Filarete, *Treatise on Architecture* (1460–64)

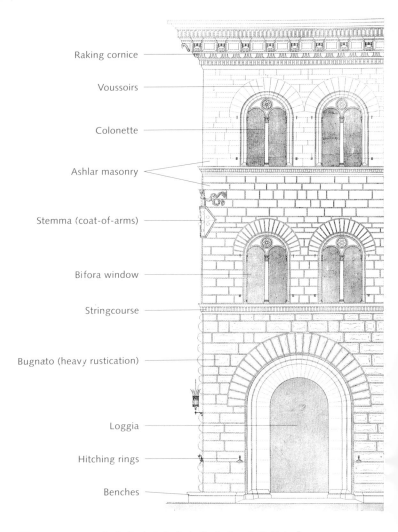

Raking cornice

Voussoirs

Colonette

Ashlar masonry

Stemma (coat-of-arms)

Bifora window

Stringcourse

Bugnato (heavy rustication)

Loggia

Hitching rings

Benches

EARLY RENAISSANCE FEATURES

Plans and massing:
Typical Mediterranean arrangement of horizontal block with central courtyard. Ground floor (*piano terreno*), often arcaded, used for shops, with benches for seating. The floor above ground level (*piano nobile*), the primary living area, sometimes duplicated by another floor above. Attic story housed servants.

Courtyards: Arcaded portico (*loggia*) forming interior courtyard. Columns carried on semicircular arches; corners terminating in a single column. Staircases moving from their typical place outdoors in the medieval era to within the arcade shelter.

Roofs: Flat tile, capped by a large cornice, a classical molding whose proportions varied, tied either to the top story or to the whole building.

Materials and colors:
Rusticated surface in rough stone (*bugnato*) at ground level retaining elements of medieval fortified family towers; upper levels of more refined drafted stone or plaster, with increasingly elegant handling. Colors distinctive to locale. in Florence a gray-brown limestone (*pietra forte*) used for exteriors, a blue-gray stone (*pietra serena*) used for contrast in white stucco interiors. Use of colored marbles for decorative insets less common.

Doors and windows:
Doors placed centrally or symmetrically. Double-light (*bifora*) windows in transition from a medieval type to semicircular profiles divided by a slender colonette, surrounded by voussoirs.

Ornament: Classical elements in stringcourses between stories and cornice molding, exterior colonettes, interior colonnade with Composite capitals. Friezes with classical motifs in glazed terra-cotta medallions.

The Medici Palace (1446–59, Michelozzo Michelozzi), Florence, set the standard for the successful merchant's residence and Florentine domestic architecture.

But the man whose work transcends and eclipses that of every other artist, living or dead, is the inspired Michelangelo Buonarroti, who is supreme not in one art alone but in all three. He surpasses not only all those whose work can be said to be superior to nature but also the artists of the ancient world whose superiority is beyond doubt. Michelangelo has triumphed over later artists, over the artists of the ancient world, over nature itself.
—Giorgio Vasari,
Lives of the Artists,
1550, 1568

Artistic activity coalesced in a revitalized Rome. The city of the popes attracted an international population—pilgrims and cardinals, diplomats and artists. It expanded to include a fine Renaissance quarter, including the Farnese Palace. A profound understanding of classical architecture and principles underlaid the desire to correctly interpret and recreate the antique domicile and the Christian temple.

Ideal form and monumentality character-

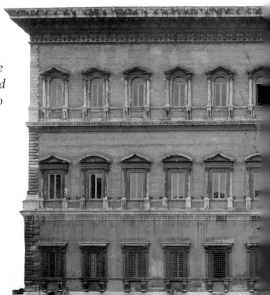

ize High Renaissance architecture. A renewed grandeur permeated design, inspired by proximity to ancient structures. Roman baths and amphitheaters profoundly influenced the conception of architectural space. The wall was no longer simply a planar surface but the expression of massed solids and voids. Plan and facade achieved symmetry in centralized form. Donato Bramante's Tempietto (1503) embodied this form and was immediately considered a classic.

Centralized Church Plans
Santa Maria delle
 Carceri (1492,
 Giuliano da Sangallo),
 Prato
Santa Maria della Con-
 solazione (1508–
 1617 Cola da
 Caprarola), Todi
Madonna di San Biagio
 (1526, Antonio
 da Sangallo
 the Elder),
 Montepulciano

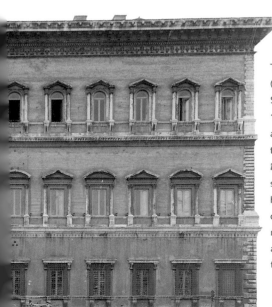

The Farnese Palace (1517–46, Antonio da Sangallo the Younger; 1546–64, Michelangelo), Rome, became the model for the future Roman palace: massive scale, a balanced horizontal block with central emphasis, rusticated doorways, and quoins to frame the composition.

HIGH RENAISSANCE FEATURES

Plans and massing:
Horizontal block with symmetry along a central axis. Often reads as two stories plus a base; disguises intermediate levels such as mezzanine and attic. *Piano terreno* in rusticated stone with voussoirs, openings for shops from the tradition of the Roman apartment building *(insula). Piano nobile* dignified by use of orders or tabernacle windows.

Courtyards: Vitruvian sequence of atrium, vestibule, and peristyle courtyard now the model. Classical principles reflected in superimposed arcades of engaged columns or pilasters carried on piers and reinforced at corners.

Roofs: Flat; masked by heightened cornice in proportion to classical order.

Materials and colors:
Travertine, a limestone, typical of Roman building; its pale gold hues sometimes covered with stucco for contrasting texture and color; could be carved for ornament. Stuccoed brick, less expensive and lighter, sometimes substituted.

Doors and windows:
Central portal prominent. Tabernacle-framed windows standard, sometimes with a straight lintel, a triangular pediment, or semicircular (segmental) pediment; symmetry and repetition.

Ornament: Paired orders; aedicules; stringcourses; balconies; classical motifs; statuary.

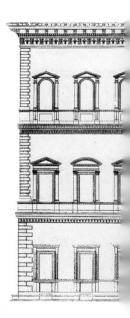

The Farnese Palace (1517–64), Rome, combined a Florentine plan with Roman scale.

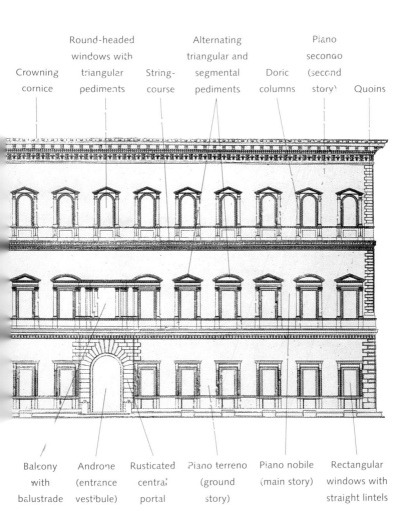

Crowning cornice

Round-headed windows with triangular pediments

String-course

Alternating triangular and segmental pediments

Doric columns

Piano secondo (second story)

Quoins

Balcony with balustrade

Androne (entrance vestibule)

Rusticated central portal

Piano terreno (ground story)

Piano nobile (main story)

Rectangular windows with straight lintels

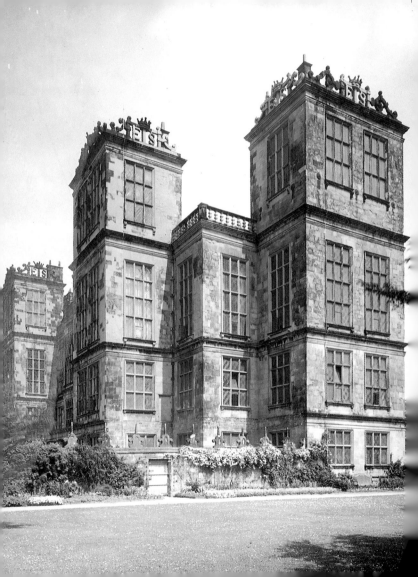

The Late Renaissance has been called Mannerist, after *maniera* (manner or style). Once characterized as a willful departure from the classical, the style is now seen as a search for rarer classical prototypes and more novel motifs. Models remained the antique as well as the work of Raphael and Michelangelo. Artistic license within the bounds of decorum was sanctioned: a villa portal could be intentionally rustic, whereas the same motif would be inappropriate for an urban palace.

An outward flow of Italian artists helped satisfy the appetites of other markets. In France, Francis I embraced the Italianate, beginning his reign by remodeling his chateau at Blois (1515). His most prestigious import was the aging Leonardo da Vinci, who designed an ingenious double-ramp stairway and ended his days in a chateau by the Loire. Most influential, however, was the arrival in France in the early 1540s of the architect and theorist Sebastiano Serlio. More than his built architecture, Serlio's books served as primers of the latest classical style for native practitioners.

The wave of Italianate style washed over England during the reign of the Tudors, as seen in Hardwick Hall (1597, Robert Smythson), Derbyshire, England.

Renaissance features enliven Longleat (1580, Robert Smythson), Wilts County, England.

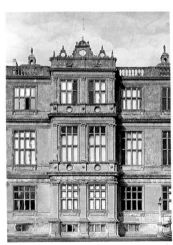

Plans and massing:
French Renaissance chateau and English country house. Overall horizontal massing and symmetry. Vestiges of corner towers in slightly projecting pavilions with setbacks for rhythmic framing of central bay (French *avants-corps)* of main block (French *corps-de-logis)*. New symmetry of rooms in relation to traditional central hall. Interior stairway a central feature.

Courtyards: Originally symmetrical; some oval. Development of a new interior feature: the long gallery (first at Fontainebleau), later taken up in Italy as an enclosed loggia in the upper-floor apartments.

Roofs: Irregular, steeply pitched roofs (often slate in northern Europe), sometimes masked by balustrades. Protruding chimneys and pavilions ornamented with small domes.

Materials and colors:
Emulation of Italian materials achieved in local or imported materials—stuccoed brick, timber and plaster, fine local stone. Restrained palettes.

Doors and windows:
Central entry emphasized by projecting masses. Increased fenestration subordinates decoration. Glazed rectangular-paned windows. Variations on tabernacle, semicircular, and dormer windows.

Ornament: Integration of ornament and design, resulting in an independent classicism.

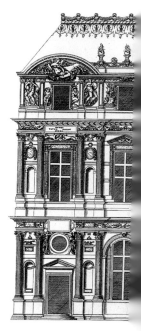

In the Louvre's Square Court (1551, Pierre Lescot), ornament dominates monumentality.

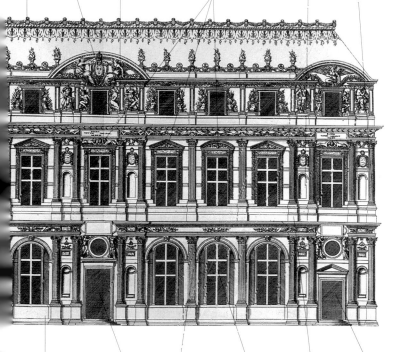

Pitched roof Relief sculpture Attic story Alternating pediments (straight, triangular, segmental) Niches Composite order

Rez-de-chaussée (ground story) Frontispiece (central pavilion) Corinthian order Tripartite bays in 5-part composition Interrupted entablature Pavilion

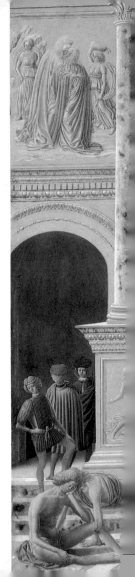

O U T S I D E

Renaissance principles imposed order on haphazard environments. Landscape architecture on a large scale was introduced. Increased prosperity led to the repopulation of cities, whose growth revolved around the market, government, and church. Public areas reflected civic pride and expressed magnificent intentions. Classical principles were applied to individual buildings and the existing urban fabric. Straight streets began to link important parts of the city.

As shown in *Presentation in the Temple* (1467, Fra Carnevale), classically embellished loggias, temples, and palaces dominated open spaces in urban areas.

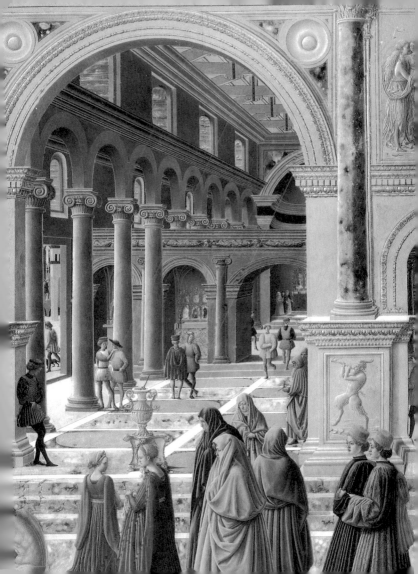

Leon Battista Alberti, shown in a self-portrait medal (1432), advocated purity and simplicity of color, such as white for temples.

Late Renaissance coloration depended not on materials but on *chiaroscuro*, the play of light and dark over the rich facade ornament, as in the Istrian stone of the Library of St. Mark (1537–91, Jacopo Sansovino), Venice.

Renaissance materials and colors are identified with particular locales. From the exotic terra-cotta decoration of Lombardy, the Istrian stone of Venice, and the cool *pietra serena* of Tuscany to the travertine of Rome, the classical ideal of purity gradually triumphed over the inset colored marbles that had enlivened Gothic and Early Renaissance facades. The architect Leon Battista Alberti demonstrated a theorist's preferences for austerity. Roman concrete was not revived as a building material in the Renaissance, so lighter-weight brick was often used in place of stone for construction; its surface was generally faced with stucco.

One compelling aspect of the Renaissance environment that has deteriorated over time was the painted exterior. *Sgraffito* work, in which a layer of tinted or white plaster was etched through with classical motifs, often grotesques, was a prized decorative technique. Rome's Ricci Palace (ca. 1525–50, Polidoro da Caravaggio) is one survivor of city pollution. Sometimes facades were embellished with elaborate fresco paintings. This fashion pervaded even Venice's inhospitable environment, but more examples survive on the mainland.

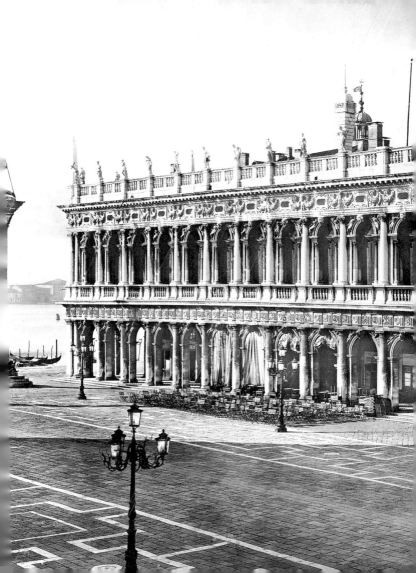

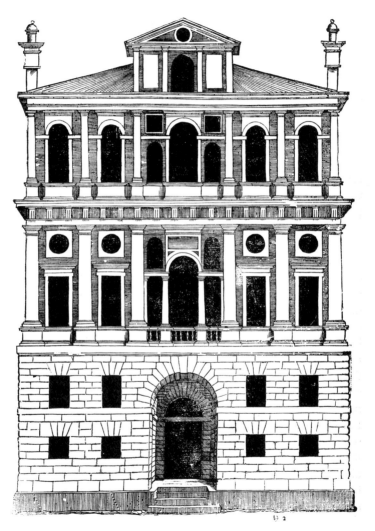

OUTSIDE

Bilateral symmetry governed the placement of doors and windows. Entrances were often elaborate, such as Bernardo Buontalenti's broken, reverse pediment of the Porta delle Suppliche (1574) at the Uffizi in Florence or the Zuccaro brothers' garden portal (1593) at their house in Rome. Gateways, although more like independent architectural structures, expanded this vocabulary, which was promulgated by Sebastiano Serlio's *Libro Estraordinario* (1551) and exemplified by Michelangelo's Porta Pia (1565) in Rome.

In Early Renaissance architecture the medieval bifora window with its pointed arches was given a classical profile. The cross-mullion window (or Guelph window) was popular in Rome. Even simpler was a semicircular stone molding often found even on modest buildings. In the High Renaissance, the aedicule (tabernacle) frame, either with a straight lintel or with triangular or segmental pediments, was preferred. In the Late Renaissance the thermal window, a large semicircular lunette inspired by the ancient Roman baths, was developed. The strict application of classical ornament relaxed later in the century, leading to more elaborate enframements, such as strapwork.

In Sebastiano Serlio's *Book IV* (1537; 1611 ed.), the central windows on the upper stories illustrate Serlian or Venetian windows, now called Palladian windows.

In my opinion, the most important error is that of making the front-ispieces of doors, windows, and loggia's broken in the middle, since these were made to keep the rain from the fabricks, and which the antient builders, instructed by necessity itself, made to close and swell in the middle. —Andrea Palladio, *The Four Books of Architecture*, 1570

COURTYARDS TO ROOFS

In the mid-1500s
Giacomo da Vignola
transformed Antonio da
Sangallo the Younger's
pentagonal plan for
Caprarola from a hilltop
fortress to a villa for the
Farnese, with a circular
courtyard cut into rock.

Visiting Caprarola
1. From the town below,
a street was cut on axis
to the villa.
2. Carriages drove to
the lower terrace,
entered a rustic portal,
and crossed a moat into
the basement of the
courtyard.
3. Visitors alighted
in the entrance atrium
and ascended by a
spiral stair.
4. Carriages continued
around the excavated
ring of the courtyard and
exited to the stables.

The incorporation of exterior space into Mediterranean houses was both natural and functional. An internal courtyard with an arcaded portico could shelter the stairway, allow viewing of theater and ceremonies performed in the open space, and provide access to working areas for tradesmen or stabling for horses. The courtyard was a public crossroads to otherwise segregated spaces. Even in monasteries, some recreation (such as reading or talking) was admitted in the cloister.

A ground-floor loggia facilitated the architectural transition between the structure and the grounds. An upper-floor loggia (enclosed as a gallery in northern climates) or even a single window balcony offered superb views. Balustrades, often topped with sculptures to crown the orders used in the elevation, muted the transition between stories and between building and sky.

Livelier rooflines were popular in northern Europe, where more steeply pitched roofs and chimney stacks intruded on the classical outline. Country houses of the English Renaissance afforded inhabitants a roofwalk, reached through pavilions and internal stairways. Prominent buildings were roofed in lead or copper rather than terra cotta.

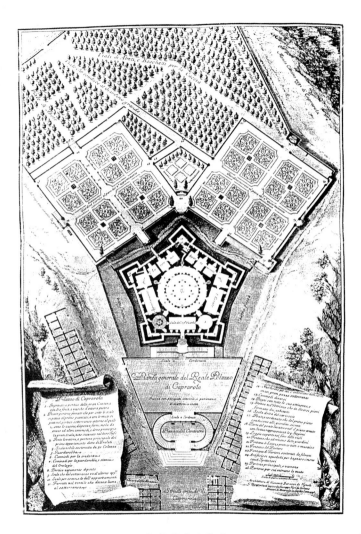

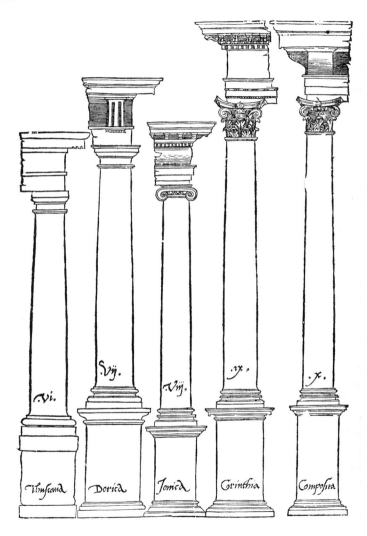

.vi.

.vij.

.viij.

.ix.

.x.

Thuscana Dorica Ionica Corinthia Composita

ORNAMENT

Ornament was seen not as extraneous embellishment but as the expressive component of a structure. According to Vitruvius, a harmonious design was one that required that nothing be added or taken away.

The classical orders and the rules of proportion that governed them were fundamental to Renaissance architectural language. Each order was associated with a particular personality that had to be appropriate to a building's function; from the heroic, muscular Doric to the slim, decorative Ionic, expressive analogies to the human body were observed. The Renaissance architect was often first a painter or sculptor because the belief was that only one who had mastered the figure could understand the anatomy of the orders. Ornament became the architect's true signature.

Competitions challenged architects to apply the classical orders to Renaissance structures. Sometimes a classical Renaissance facade masked a medieval interior, as with Leon Battista Alberti's Tempio Malatestiano (1450) in Rimini. Renaissance style often first appeared in other countries as a new face for town halls, palaces, and cathedrals.

Drawing after the antique was indispensable training for architect and artist alike. This example is from Sebastiano Serlio's *Book III* (1540).

The orders at a glance: Sebastiano Serlio presented the five classical orders (Tuscan, Doric, Ionic, Corinthian, and Composite) in his *Book IV* (1537), published before *Book III*.

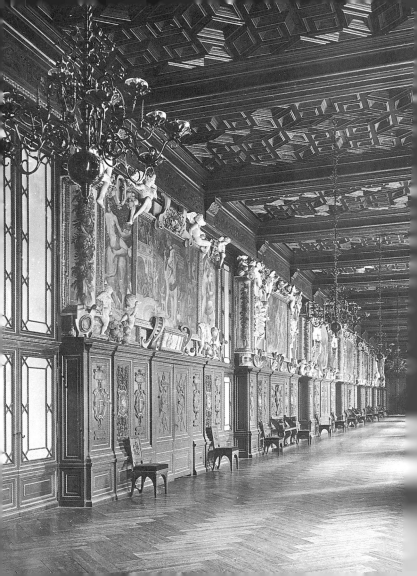

INSIDE

Ideal plans were found mainly in drawings and treatises. In actual buildings circumstances often forced a compromise, leading to harmoniously proportioned exteriors that did not reflect interior divisions. The classical ideal of symmetry and correspondence of architectural parts was difficult to achieve and somewhat contrary to the expression of function. Inside, sequences of rooms were arranged according to level of access, from public to private.

Strapwork scroll decoration such as Rosso Fiorentino's in the Gallery (1540) of Francis I at Fontainebleau in France became a Mannerist hallmark.

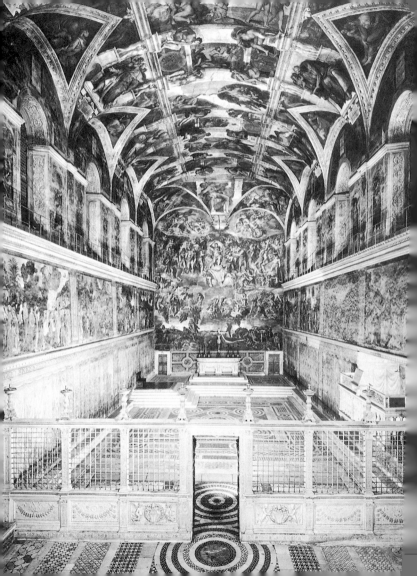

FLOORS, WALLS, AND CEILINGS

The most common flooring in Italy was terrazzo (brick tile), which varied according to location, local craftsmanship, and economic status. Inlaid patterns of rich marbles appeared only in the houses of the very wealthy. Colored marble floors were more common in churches, often set in elaborate checkerboards or spiral wheels. Another colorful flooring in limited use was majolica (painted ceramic tile). Generally floors reflected the rich, burnished hues of terra cotta, whether set as tiles or crushed to form a composite surface laid in artful patterns and rolled to a lustrous finish.

Stone, brick, and plaster were common materials for walls. Majolica was found as well on walls and ceilings, often featuring the heraldic devices of the patron.

Ceilings could be vaulted but were usually exposed beams, with painted or carved decoration, or dropped soffits with framed compartments. The most imitated classical motif was coffering, which could be treated in recessed perspectival squares or octagons, carved in stone or wood, gilded, and adorned with rosettes. Roman vaulting and domes were used in churches and in Andrea Palladio's domestic architecture.

The Sistine Chapel (1481, Baccio Pontelli), Vatican City, combines real marble floors and screens as well as fictive frescoes of gold brocade wall hangings and a marble ceiling.

Michelangelo, depicted in this 1564 bust by Daniele da Volterra, served many popes. Julius II commissioned the ceiling painting of the Sistine Chapel, and Paul III commissioned the *Last Judgment* (1541).

The association of form and function allowed the fireplace to make a statement. This Corinthian fireplace, shown in Sebastiano Serlio's *Book IV* (1537), displays a flaming globe—a fantasy of fire.

Public Fountains

When architects had the opportunity, they enhanced the climate's natural qualities by a judicious choice of building site—prizing good air circulation, avoiding damp ground, and regulating orientation to the sun. Fireplaces, beginning with the kitchen hearth, were the main source of heat, along with small portable charcoal braziers and warming pans for personal comfort; tiled stoves were in demand in northern Europe. The fireplace used the same expensive building materials, mainly stone and marble, as other decorative areas, although it was usually rendered with classical ornament in beautifully carved details. A prominent sloping hood over the mantel was gradually reduced as the fireplace became more flush with the wall, further emphasizing a classical profile.

Bathrooms in elite residences were among the few rooms to be served by a system of piped heat, or stoves, although such systems were well known from Roman baths and their descriptions in Vitruvius. Andrea Palladio admired a similar system used for air conditioning, describing how cool air was vented through subterranean ducts. The majority of households obtained water from public fountains.

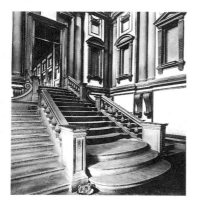

Michelangelo's organic approach to architecture is seen in his stairway (1524–34, installed 1559) for the Laurentian Library, Florence, cascading from the reading room to the vestibule.

With the spiral staircase (1515) at the chateau of Blois, Francis I introduced Renaissance architecture to France.

During the Renaissance stairs changed considerably: the exterior staircase was gradually brought into the shelter of the courtyard and eventually into the interior. One problem the Renaissance architect faced was the correct superimposition of classical orders, especially with the typical winding, or spiral, stairs. Donato Bramante's solution in the Vatican Palace (1512) was much admired. The period also favored double-flight stairs with a dog-leg turn.

The social unit of the family was superseding that of the larger clan, with the accompanying impulse toward domestic privacy. Access to specific rooms was carefully controlled. One planning development was a series of rooms *en suite*, the most public hall at the perimeter and the most private at the core, leading to the idea of the apartment. The work of Andrea Palladio provided architects of the Late Renaissance and beyond with "blueprints" for the ideal layout: geometric plans based on harmonic ratios, a symmetrical arrangement of rooms around a central hall.

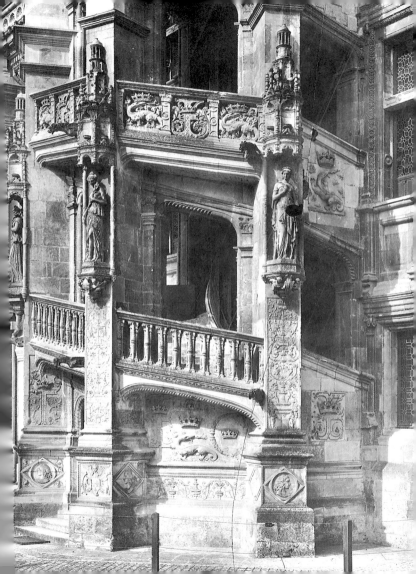

FINISHING TOUCHES

The Renaissance interior was functionally furnished, often focused on insulating the predominantly stone buildings against winter's cold and summer's heat. Even so, fresco decorations often substituted for more costly furnishings such as tapestries or paneling. Paintings were part of the furniture, from small devotional images of the Madonna and Child to family portraits and sculptured busts. Decoration usually reflected the room's purpose.

Wood paneling with motifs *all'antica* warms the interior of this chamber in Domenico Ghirlandaio's Florentine fresco *Birth of the Virgin* (1490).

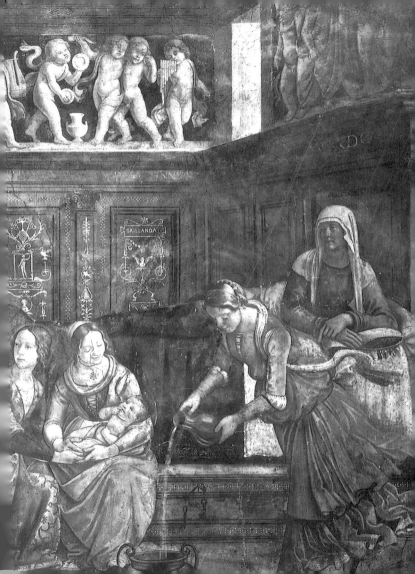

FURNITURE

The setting for the *Dream of St. Ursula* (1495, Vittore Carpaccio), a detail of which is shown here, is an elegant bed with a tester, canopy, headboard, and the luxurious comfort of pillows.

This chair, said to be owned by Petrarch, was typical of the portable furniture of the Renaissance period.

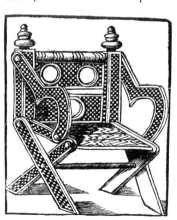

During the Renaissance most furniture was set around the perimeter of a room. A typical type of seating was the X chair, which could be folded and moved, although long tables set on trestles for dining might take advantage of built-in benches. Decorative motifs often included the family's heraldic devices as well as classical molding and grotesques.

A common type of furniture associated with the bedroom and other rooms was a *cassone*, a large, low chest that was often part of a dowry. In the Early Renaissance these tended to be painted with iconographically apt scenes from mythology and ancient history, such as the marriage of Peleus and Thetis or the love of Venus and Mars. In the sixteenth century painted scenes were supplanted by carved sculptural decoration.

Beds were substantial. The classicizing touch could be applied to the wood framework, especially a headboard, which might have an intricately carved molding and be built into the wall. Sometimes the bed enclosure practically constituted a room within a room.

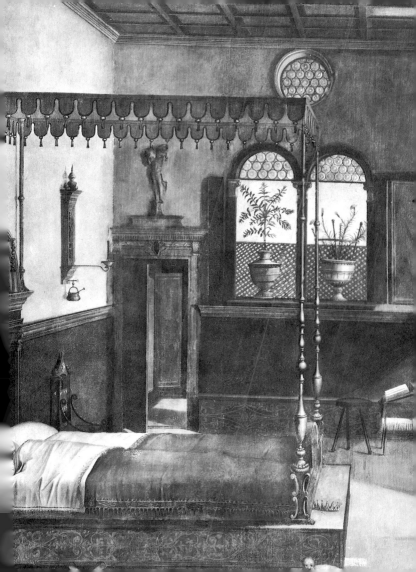

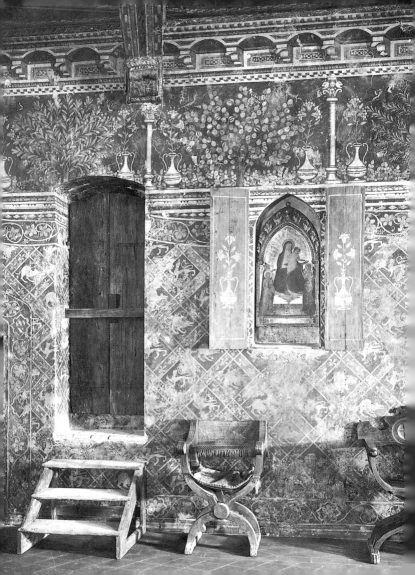

WALL COVERINGS

Some of the great masterworks of Western art are wall hangings and paneling. Valued for their decorative qualities, they could also provide insulation. Tapestries were among the costliest, and the High Renaissance in Italy saw a revival of figurative subjects. Wall decoration tended to be divided into horizontal layers: at the lower level, rich, brocaded wall hangings for special occasions or frescoes of these; then, large horizontal bands of decoration; next, the room's architectural framework, with spaces for further decoration; and finally the ceiling.

Perhaps the most influential tapestries were Raphael's for the Sistine Chapel. Full-size colored cartoons (1516) executed in reverse were sent to Brussels to be woven. Sets were acquired by England's Henry VIII and France's Francis I. Flanders was preeminent in the production of woven textiles, but the Medici dukes in Florence established their own center of manufacture to make tapestries for their splendid palaces.

In sixteenth-century Venice frescoes were supplanted by large oil paintings on canvas, both in churches and palaces. Another expensive wall covering was leather, which was stamped, gilded, or painted.

The garden was a typical Renaissance motif, here used to enliven the painted interior (ca. 1400) of the Davanzati Palace, Florence.

Others decorate their halls with hangings of Arras and Flanders . . . ; rugs and moquettes from Turkey or Syria, barbaresque carpets and tapestries; painted hangings by good masters, Spanish leather ingeniously wrought. . . . I favor and praise all these ornaments too, because they are a sign of judgement, culture, education and distinction.
—Sabba di Castiglione, *Ricordi,* 1546

FLOOR COVERINGS

Renaissance Centers for Crafts and Trades

Florence: Wool

Lucca: Silk

Brussels: Tapestries

Genoa: Cut velvets

Nuremberg: Clocks

Venice: Glass

Milan: Armor

From floor carpets to bed hangings, fine wool cloth to sheer silk veils, the cloth industry dominated the Renaissance economy. Such accoutrements grace the Virgin's chamber in this detail from an early fifteenth-century *Annunciation* (anonymous).

During the Renaissance flooring was commonly exposed. For this reason it might be highly decorated. Oriental carpets were not only placed on the floor but also used as wall hangings and table draperies. Like tapestries, such carpets were highly valued. Being portable, they could accompany the patrons as they moved between residences or be brought out for different seasons or special events. Public festivals were marked by the colorful display of brightly patterned carpets hung from windows. They were imported as part of the luxury trade in silk and spices with the East. In this way many motifs from Eastern lands were incorporated into the decorative vocabulary of Italy.

Woven rush mats, some decoratively patterned, would be used on terrazzo tile floors to keep the chill off and the dirt out. Furniture might be set on a low wooden platform to elevate it from the floor. For festivities flowers were strewn over the floor in the banqueting room.

In poorer dwellings the floor often consisted only of beaten earth. Rushes strewn over the dirt frequently constituted the sole floor covering; for hygiene sweet-smelling herbs were mixed with the rushes.

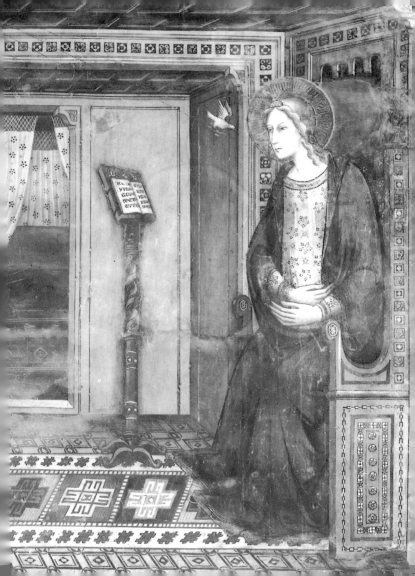

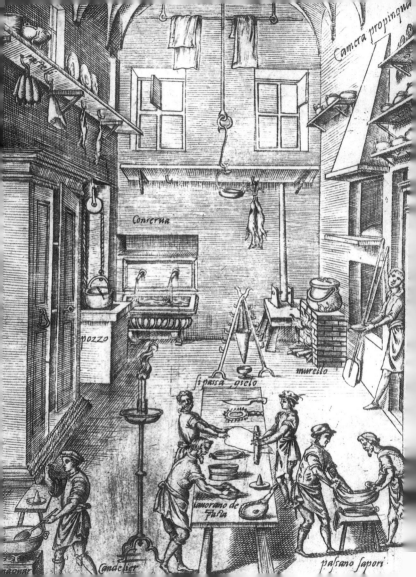

Camera propinqua

Conserua

pozzo

si passa gielo

murello

lauorano de Pasta

Candelier

passano sapori

In its reliance on candles, oil lamps, and fires for lighting, the Renaissance was not significantly different from the classical period. Household and workplace were bound by farmers' hours—dawn to dusk. Light was a luxury.

Large, high-quality wax candles, carried ceremonially in processions, were an important element of church and public ritual. Even in the most sumptuous households, the building and immediate grounds were illuminated in the evening only for special events, as the cost of such candlepower could be enormous.

In the interior, reflective surfaces magnified the effects of light, glinting off gold-ground paintings and metallic threads in hangings, as well as the increasingly popular mirror. Natural light was maximized. Glass-paned windows could be found even in some moderate households, but more common were oil-lined linen panels *(impannate)* stretched over a frame and set into the embrasure. Shutters were ingeniously hinged to moderate light and drafts. Varied wall brackets, sconces, chandeliers, and hanging lamps were executed in a range of materials, from iron and bronze to gold and silver.

[Sangallo's design for St. Peter's] . . . has not provided any fresh means of lighting, while there are so many gloomy lurking holes both above and below that any sort of knavery could easily be practiced, such as the hiding of banished persons, the coining of false money, the rape of nuns, and other misdemeanors.
—Michelangelo, letter to Bartolomeo Ammannati, 1555

Important household furnishings included lighting fixtures such as the tall candle-holder shown at left in Bartolomeo Scappi's *Opera* (1570).

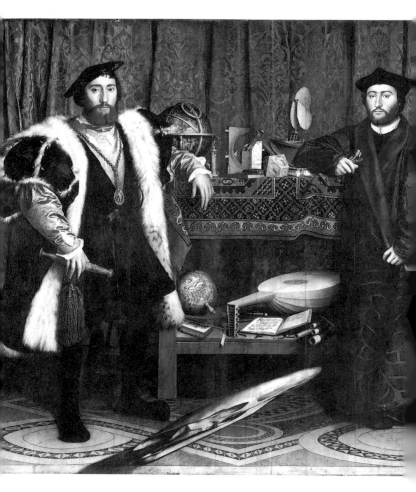

DECORATIVE OBJECTS

From sconces to andirons, no object was too mean to be treated as a work of art. Perhaps no salt and pepper shaker has ever rivaled Benvenuto Cellini's, with its allegorical subject of Neptune and Ceres and its elegant form (1540s), no drinking cup the Tazza Barovier (1460s), a product of the developing Venetian industry of glasswork. Of course, these were extraordinary objects for the most exquisite appetites, but they shared with other objects that graced humbler tables and were used daily similar precepts of Renaissance style, particularly the recovery of antique themes such as winged *putti*.

Another industry that flourished was majolica. Quantities of tableware were produced in colored glazes and decorative styles particular to centers such as Gubbio, Faenza (which gave its name to *faïence),* and Urbino. Widespread distribution meant the transmission of Renaissance painting styles, classical subjects, and decorative vocabulary.

Collectors proudly displayed acquisitions of ancient busts, coins, metals, and gems or commissioned artists to recreate works after the ancient manner, especially small bronze sculptures and plaquettes by such artists as Andrea Riccio and Antico.

Still-life objects exalt humanist activities and demonstrate artistic perspective in the trompe l'oeil *intarsia* (marquetry) paneling (ca. 1480, Baccio Pontelli) in the Duke of Urbino's study (above) and in Hans Holbein's *French Ambassadors* (1533) (opposite).

The notion of progress propelled the Renaissance. In his *Lives of the Artists* Giorgio Vasari praised artists' progression from a decadent to a good modern style and defined the five qualities "that made modern art even more glorious than that of the ancient world"—rule, order, proportion, drawing, and the ideal. Their universal application helped bring about the triumph of Renaissance style, transforming European culture on the brink of the modern era.

The chateau (1519–50s, Domenico da Cortona) of Chambord, France, embraced Renaissance planning in its bilateral symmetry and Greek-cross form.

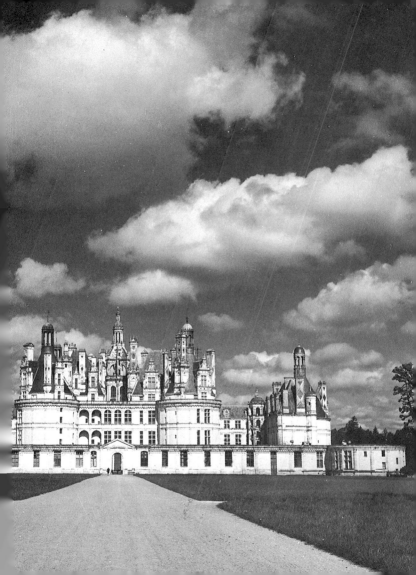

The concept of home was a far more public one than it is today. Rulers, nobles, and merchants carried out their transactions with the outside world in the great halls or more intimate apartments of their fine palaces. Such grand residences required staffs to run them—administrators to cope with the affairs of state or commerce, the housing of dependents, and visits of friends. One of the more private rooms in the Renaissance household was the study. Famous men and women furnished these rooms in the latest style, eager to demonstrate their learning. Humanist accoutrements cluttered the cupboards.

In the city, descending the scale of the social order, public and private were still mixed as business and domestic purposes were combined in the same building. The tradition of shops on the ground floor extended back to the Roman *insula*, thereby granting this arrangement the imprimatur of classical architecture. Commodious elements of Renaissance style lent a new degree of comfort to more domestic environments.

The High Renaissance–style Roman palace was exemplified by the Caprini Palace (1510, Donato Bramante), which served as Raphael's residence and studio.

In the Massimo alle Colonne Palace (1532), Rome, Baldassare Peruzzi balanced two adjacent facades to cope with an irregular site.

VILLAS AND FARMHOUSES

The nobility of the central wing of the Villa Barbaro (1557–ca. 1570, Andrea Palladio), Maser, flanked on either side by farm buildings, is proclaimed by the application of a classical temple front to the facade, an uncommon motif in domestic architecture until Palladio.

The renewed vigor concentrated in the Renaissance city bred an equally strong desire to escape it at times—through an evening's retreat to the suburbs or a day's hunting in the country.

In central Italy imperial pleasure villas predominated. Those built in the suburbs of Rome were used for relaxation, entertainment, or ceremonial purposes such as the formal entry of important visitors; others in the outlying hills provided respites from the city during the summer and times of plague.

In northern Italy Roman republican villas, possibly more palatable to the Venetian republic's political identity or more attuned to economic life there, prevailed. The ideal was a combination of the villa and the farmhouse, including practical, vernacular-style buildings refurbished with Renaissance elements for agriculture. Using the tenets of Renaissance style, Andrea Palladio devised a formula for the country estate, where the owner could manage his agricultural interests and pursue the good life.

The agreeable, pleasant, commodious, and healthy situation being found, attention is to be given to [the villa's] elegant and convenient disposition.
—Andrea Palladio, *The Four Books of Architecture*, 1570

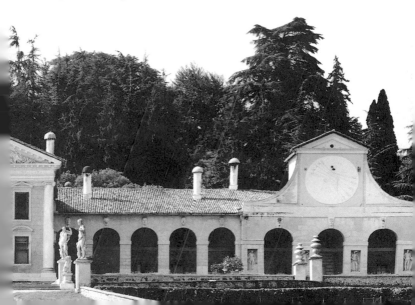

PUBLIC BUILDINGS

Michelangelo chose a
monumental order to
unify the elevations of
the Capitoline palaces
(1538–ca. 1660), Rome,
a feat captured in a
1755 painting by
Antonio Canaletto.
Michelangelo's design
for St. Peter's used the
same colossal order.

Two important areas of public life were the market and the city hall. The open nature of markets made them adaptable to the classicizing of the arcaded portico. The thriving communes of the medieval period left a legacy of town halls in Italian cities. One task that fell to the Renaissance architect was to modernize these buildings in a style that befitted a seat of government. Stylistic retrofitting was difficult, especially because the classical system of proportions was too rigid to apply easily. The town hall of Vicenza, known as the Basilica (1549) because of its shape, posed such a problem; Andrea Palladio finally decided instead to create a screen around the building using the motif now known as the Palladian window.

The public complex with the most potent reminders of the classical past was the Capitoline Hill of Rome, once the center of the world and still the site of public ceremony. The Hapsburg emperor Charles V's visit in 1536 spurred a commission to Michelangelo to create a new civic center in the Renaissance style. Michelangelo's trapezoidal plan regularized building relationships, harmonized facades, and formalized the entry with a ramp *(cordonata)* to the city below.

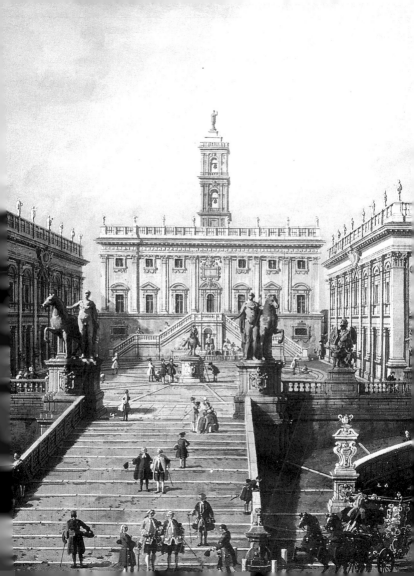

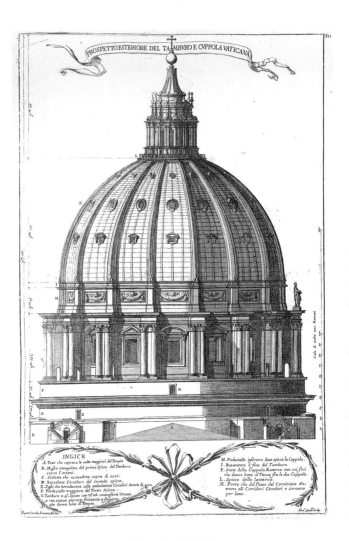

PROSPETTO ESTERIORE DEL TAMBVRO E CVPPOLA VATICANA

911

INDICE

A. Tevi che coprano le uolte maggiori del Tempio
B. Masso triangolare del primo Spico del Tamburo sopra l'arcani.
C. Scaleto che ascitadono sopra di esso.
D. Zoccolone Circolare del secondo spico.
E. Pogli che introducono uelle ambulationi Circolari dentro di esso
F. Piedestallo maggiore del Toro e Spico.
G. Tamburo e g.i Spicoe con n.o 28. contraforti Ornato e con statue sopra u firimenti e finestre che danno lume al Tempio.

H. Piedestallo inferiore doue spicca la Cuppola.
I. Basamento e fino del Tamburo.
K. Sesto della Cuppola Esterna con sui fori che danno lume al Vacuo fra le due Cuppola.
L. Spicco della lanterna
M. Porte che dal Piano del Corniciane entrano alli Corridori Circolari e seruono per lume.

CHURCHES

If perfection could be a shape, it would be the circle. This idea was given weight by the emergence of Neoplatonic philosophy influenced by Euclid and Pythagoras. Architects and theorists alike believed the centralized plan to be the ideal church plan. It exhibited a symbolic congruence between form and spirituality, a similarity shared by the most impressive extant building from ancient Rome—the Pantheon.

The paradigm of a domed, centralized building conflicted with most liturgical practices, which required a particular placement for the altar, celebrant, and audience. Liturgical considerations dominated development of the Counter Reformation church, including removal of the choir screen blocking a view of the altar. Reformation churches began by removing images.

When Pope Julius II decided to rebuild the premier church of Christendom in 1506, he initiated a campaign whose transformations mirror the changes in Renaissance ideals and style. The new St. Peter's reflected a desire to compromise, retaining the practical advantages of the basilica while integrating the expressive quality of the centralized form.

The dome of St. Peter's was finally constructed in the 1590s by Giacomo della Porta, who adapted the model by Michelangelo designed in 1558–61.

This medal (ca. 1466, Sperandio) commemorates Francesco Sforza, duke of Milan. Possibly a proposal for his mausoleum, it documents interest in domed plans.

GARDENS

The sound of water was essential to the conception of the garden. The ingenuity of Renaissance hydraulic engineers created the magnificent tones that could issue from a water organ, a central feature of the garden at the Villa d'Este in Tivoli.

Grand Gardens

Villa Medici (1537–90s, Niccolò Tribolo), Castello

Boboli Garden (1549–88, Niccolò Tribolo), Pitti Palace. Florence

Sacred Wood (1552–85, Pier Francesco Orsini), Bomarzo

Villa Medici (1569–ca. 1600, Bernardo Buontalenti), Pratolino

The Italian garden was designed according to the same formal principles that governed architecture. Plantings were arranged in symmetrical and geometrical forms. Typical garden elements included terracing, parterres, pergolas, quincunx groves, and grottoes. A garden frequently contained iconographical content that could be displayed through a program of sculpture and choice of plantings. An apple tree might be an allusion to the Gardens of the Hesperides as well as the Garden of Eden, as at the Villa d'Este garden (1550–72, Pirro Ligorio) in Tivoli.

Fountains were especially favored as conveyors of meaning, particularly as reminders of the Font of Parnassus, as at Villa Lante (after 1568, Giacomo da Vignola) in Bagnaia. Small, autonomous buildings were placed in gardens to take advantage of the views and prevailing winds and often used for dining al fresco. For example, the Villa Belvedere was connected to the Vatican Palace by Donato Bramante's monumental courtyard (1505–60s), the first essay in Renaissance landscape architecture. Formal gardens particularly in the villas of church dignitaries around Rome grew in ambition and changed in scale from gardens to parks.

IN STYLE

THEATERS

Among all the things that may bee made by mens hands, thereby to yield admiration, pleasure to sight, and to content the fantasies of men; I thinke it is the placing of a Scene, . . . built by Carpenters or Masons, skillful in Perspective worke, great Palaces, large Temples, and divers Houses, both neere and farre off.
—Sebastiano Serlio, *Book II*, 1545, 1611

For a learned academy in Vicenza, Palladio designed the Teatro Olimpico (1584) after the antique. Permanent fixed perspective flats represented the city behind a proscenium arch.

In the Early Renaissance the *sacra rappresentazione*, a form of sacred drama performed in public spaces, became popular. Saints' days and biblical narratives were celebrated by reenactment. Demand grew for convincing stage scenery. In the church of the Santissima Annunziata (1439) in Florence, Filippo Brunelleschi used perspective to stage the illusion of flight along a trajectory.

A desire to revive classical drama was matched by an interest in recreating the ancient theater. Most theaters were temporary structures erected where there was insufficient interior or exterior space to house the scenery, the primary architectural feature. A garden loggia in a palace or villa also might be used for performances, as at the Villa Farnesina in Rome. One private theater complex with a central building for music was built for Alvise Cornaro in Padua beginning in 1524. Only in the late sixteenth century did the idea of permanent theaters take hold, such as Bernardo Buontalenti's Medici Theater (1586) in the Uffizi Palace in Florence.

The sixteenth century also was the turning point for a new musical form, the opera. As grander spectacles took the stage, sets and machinery became increasingly elaborate.

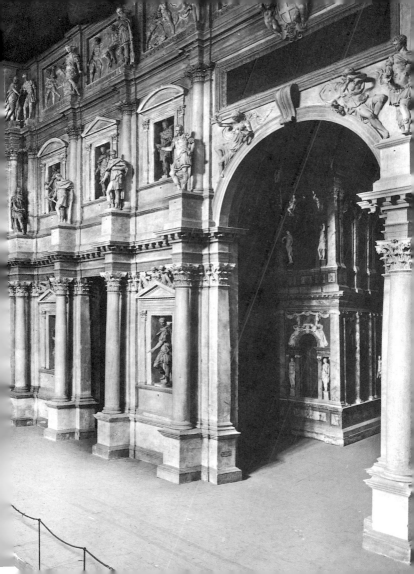

PIAZZAS

All the world was indeed a stage, as Shakespeare said, and the Renaissance city itself was the largest theater for public ritual. From mundane trips to the local fountain for water and a chat with neighbors to sermons and plays performed in church squares, from grand spectacles of mock sea battles staged in flooded courtyards to public processions and carnival events—much of Italian public life was conducted outdoors.

Civic life often revolved around market, government, and ecclesiastical centers in which exterior space was part of a building or was created by a complex of buildings. These centers, which had grown up more or less naturally in the medieval city, began to be organized according to the principles of Renaissance style. The Italian city of Corsignano was transformed along such ideals and its name changed to Pienza, after Pope Pius II, who had envisioned its new plan (1459–64, Bernardo Rossellino). Within an established urban fabric little more than a symmetrical realignment of arcaded facades in the new style could be achieved, although substantial transformations were made to city centers such as Venice's Piazza of St. Mark (from 1513) and Rome's Capitoline Hill (from 1536).

Notable Piazzas

Piazza Ducale
 (1494), Vigevano
Piazza del Popolo
 (1509), Ascoli Piceno
Piazza Santissima
 Annunziata (1516–
 ca. 1600), Florence
Piazza Maggiore
 (ca. 1560, Giacomo
 da Vignola), Bologna

With his idealized perspective drawings, Jan Vredeman de Vries of the Netherlands helped carry the Renaissance style to northern Europe in the late sixteenth century. His last work, *Perspective* (1604), mixed architectural fantasies with lessons in perspective, which he called the "most famous art of eyesight."

THE IDEAL CITY

Piero di Cataneo devised this scheme for a nine-sided city with a citadel. Throughout the Renaissance Albertian geometry defined the ideal city.

The principal ornament to any city lies in the siting, layout, composition and arrangement of its roads, squares and individual works; each must be properly planned and distributed according to use, importance and convenience. For without order there can be nothing commodious, graceful and noble.
—Leon Battista Alberti, *Ten Books of Architecture*, 1485

The ideal city in Renaissance thought symbolized the replication of the cosmos and social order and was functional in design and classical in style. It was realized far more frequently on canvas and panel than in stone and brick. Utopian and humanist concerns still outweighed new science and engineering. From the single building to the whole entity, the composition of the ideal city radiated harmony and rationality.

Some military towns were built according to an ideal plan. Palmanova, in northern Italy, was designed on a star-shaped radial plan with angled bastions (1593, Giulio Savorgnan), a type that later spread throughout Europe through the projects of Sébastien de Vauban. The logical outcome of such specialized professions as military architect and engineer was a change in the face of the future city according to criteria other than idealistic ones. A later age would oversee this transition, when architecture was no longer dominated by painter-sculptors whose training prepared them to apply principles of design, perspective, the human body, and the anatomy of the orders—although this Renaissance knowledge became absorbed into the profession of architecture.

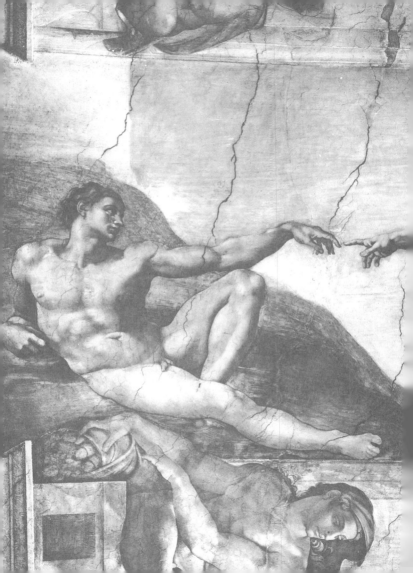

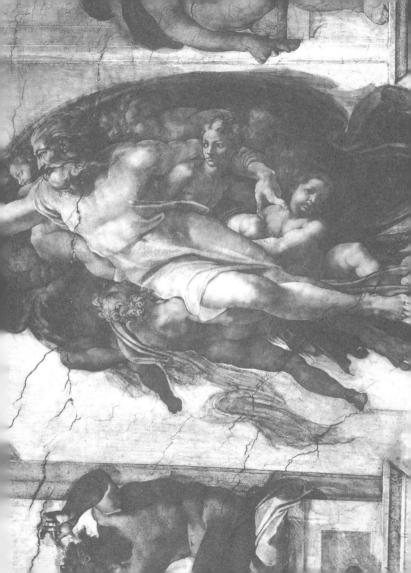

Endpapers: Detail from *Creation of Adam* (1512, Michelangelo), Sistine Chapel, Vatican City.

Page 1: *Vitruvian Man* (1435, Leonardo da Vinci).
Page 2: *Study of Bramante's Tempietto* (1588, Federico Barocci).
Pages 4–5: Baltimore panel of the *Ideal City* (anonymous, late 15th century).

Produced by Archetype Press, Inc.
Project Director:
Diane Maddex
Editor:
Gretchen Smith Mui
Editorial Assistant:
Kristi Flis
Art Director:
Robert L. Wiser

10 9 8 7 6 5 4 3 2 1

Other titles in the Abbeville StyleBooks™ series include *Art Deco* (ISBN 1-55859-824-3); *Art Nouveau* (ISBN 0-7892-0024-4); *Arts & Crafts* (ISBN 0-7892-0010-4); *Early Victorian* (ISBN 0-7892-0011-2); and *Gothic Revival* (ISBN 1-55859-823-5).

Library of Congress Cataloging-in-Publication Data
Cooper, Tracy Elizabeth
Renaissance / Tracy E. Cooper.
 p. cm. — (Abbeville stylebooks)
Includes bibliographical references and index.
ISBN 0-7892-0023-6
1. Art, Renaissance—Italy. 2. Art, Italian. 3. Art, Renaissance—Influence. I. Title. II. Series.
N6915.C66 1995 95-20978
709'.45'09024–dc20 CI

CREDITS

INDEX

RECOMMENDED READING

Ackerman, James. *Distance Points: Essays in Theory and Renaissance Art and Architecture*. Cambridge, Mass.: MIT Press, 1991.

Argan, Giulio Carlo. *The Renaissance City*. New York: Braziller, 1969.

Burckhardt, Jacob. *The Civilization of the Renaissance in Italy*. 1860. Reprint New York: Viking Penguin, 1990.

Burke, Peter. *The Italian Renaissance: Culture and Society in Renaissance Italy*. 1972. Rev. ed. Princeton: Princeton University Press, 1986.

Coffin, David. *The Villa in the Life of Renaissance Rome*. Princeton: Princeton University Press, 1979.

Encyclopaedia of the Renaissance. Thomas Bergin, consulting ed.; Jennifer Speake, gen. ed. London: B. T. Batsford, 1987.

Gilbert, Creighton. *History of Renaissance Art Throughout Europe*. Englewood Cliffs, N.J.: Prentice-Hall and Abrams, 1973.

Hale, John. *The Civilization of Europe in the Renaissance*. New York: Atheneum, 1994.

Lazzaro, Claudia. *The Italian Renaissance Garden*. New Haven: Yale University Press, 1990.

Levensor, Jay, ed. *Circa 1492: Art in the Age of Exploration*. New Haven: Yale University Press, 1991.

Millon, Henry, and Vittorio Lampugnani. *The Renaissance from Brunelleschi to Michaelangelo: The Representation of Architecture*. Milan: Bompiani, 1994.

Murray, Peter. *The Architecture of the Italian Renaissance*. 1963. Rev. ed. London: Thames and Hudson, 1986.

Shearman, John. *Mannerism*. 1967. Reprint. New York: Viking Fenguin, 1978.

Thornton, Peter. *The Italian Renaissance Interior, 1400–1600*. New York: Abrams, 1991.

Wittkower, Rudolf. *Architectural Principles in the Age of Humanism*. 1949. New York: Norton, 1971.

ADDITIONAL SITES TO VISIT

*See additional places
cited in the text.*

Albrecht Dürer's House
(15th c.)
Nuremberg, Germany

Ariosto's House
(ca. 1500)
Ferrara, Italy

**Avoncroft Museum
of Building** (15th–
16th c.)
Bromsgrove, England

Botanical Garden (1545)
Padua, Italy

Cervantes's Birthplace
(early 16th c.)
Madrid, Spain

**Davanzati Palace
and Museum of Historic
Florentine Houses**
(late 14th–15th c.)
Florence, Italy

**El Greco's House
and Museum** (16th c.)
Toledo, Spain

Erasmus's House (1515)
Brussels, Belgium

House of Jacques Coeur
(1440–50)
Bourges, France

**Joachim du Bellay
Museum** (16th c.)
Liré, France

Landshut Museum
(1536–43)
Landshut, Germany

**Leonardo da Vinci
Museum of Science
and Technology**
(16th–18th c.)
Milan, Italy

Lope de Vega House
(1587)
Madrid, Spain

Michelangelo's House
(1508)
Florence, Italy

**Museum of the Middle
Ages and Renaissance**
(15th c.)
Bologna, Italy

Petrarch's House
(14th–16th c.)
Arquà Petrarca, Italy

Raphael's Birthplace
(15th c.)
Urbino, Italy

**Royal Monastery
of San Lorenzo** (1584)
Madrid, Spain

Shakespeare's Birthplace
(16th c.)
Stratford-on-Avon,
England

Vasari's House (1548)
Arezzo, Italy

SOURCES OF INFORMATION

**Association des
Amis de la Fondation
du Patrimoine**
Palais de Chaillot
1, place du Trocadéro
75116 Paris, France

**Association des Vieilles
Maisons Françaises**
93, rue de l'Université
75343 Paris, France

**Centre Canadien
d'Architecture/
Canadian Centre
for Architecture**
1920, rue Baile
Montreal, Quebec
H3H 2S6, Canada

**Centro di Studi per la
Storia dell' Architettura**
via Teatro Marcello 54
00186 Rome, Italy

**Centro Internazionale
di Studi d'Architettura
Andrea Palladio**
Domus Comestabilis
piazza dei Signori
Casella Postale 769
36100 Vicenza,
Italy

**Centro per la
Conservazione dei
Giardini Storici**
villa Il Ventaglio
via delle Forbici 24–26
50133 Florence, Italy

Garden History Society
5 The Knoll
Hereford HR1 1RU,
England

**Istituto Nazionale di
Studi sul Rinascimento**
Palazzo Strozzi
piazza Strozzi
I-50123 Florence, Italy

**Renaissance Society of
America**
24 West 12th Street
New York, N.Y. 10011

Shakespeare Centre
Henly Street
Stratford-on-Avon
Warwickshire
CV37 6QW, England

**Society for
Renaissance Studies**
Royal Holloway and
Bedford New College
University of London
Egham Hill
Egham, Surrey
TW20 0FX, England

**Society of Architectural
Historians**
Charnley House
1365 Astor Street
Chicago, Ill. 60610

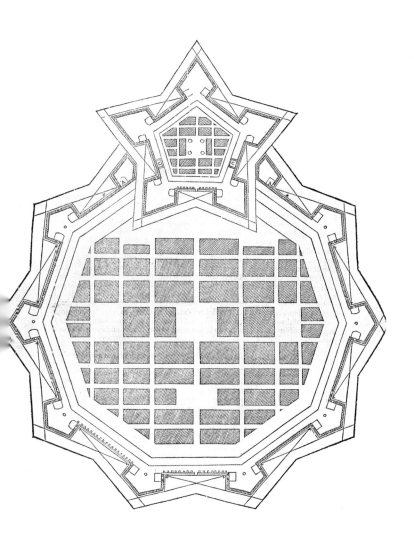

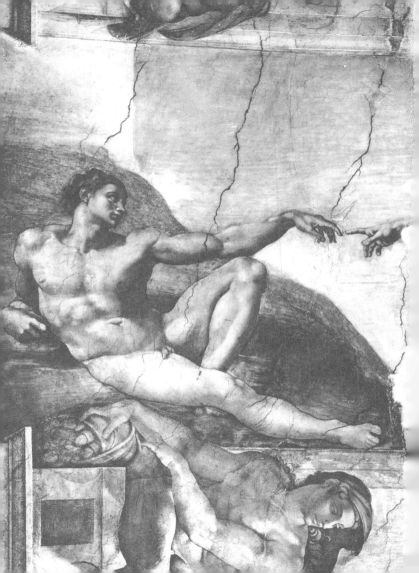

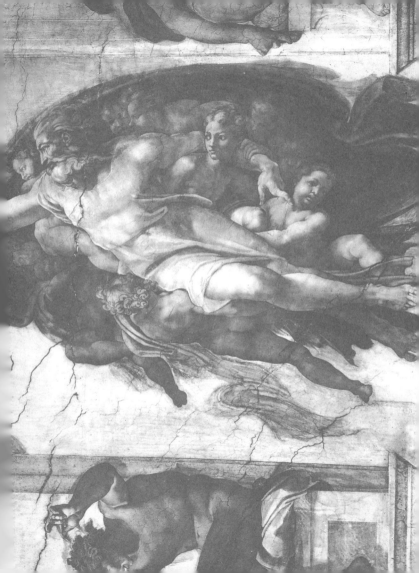